For Carol, Daisy & Casey
with Love

smallfellow
press

A Division of Tallfellow Press, Inc.
and Every Picture Tells a Story…, Inc.
1180 South Beverly Drive , Los Angeles, CA 90035

The paintings from this book are created in mixed media on board.
Production supervision by Art Works Pasadena, California

ISBN 0-9676061-8-7
First Edition First Printing
Printed in Hong Kong
Text and illustration © 2001 Joe Murray

You can find the art of Joe Murray and many other illustrators at:
everypicture.com

Who Asked the Moon to Dinner?

by Joe Murray

smallfellow press

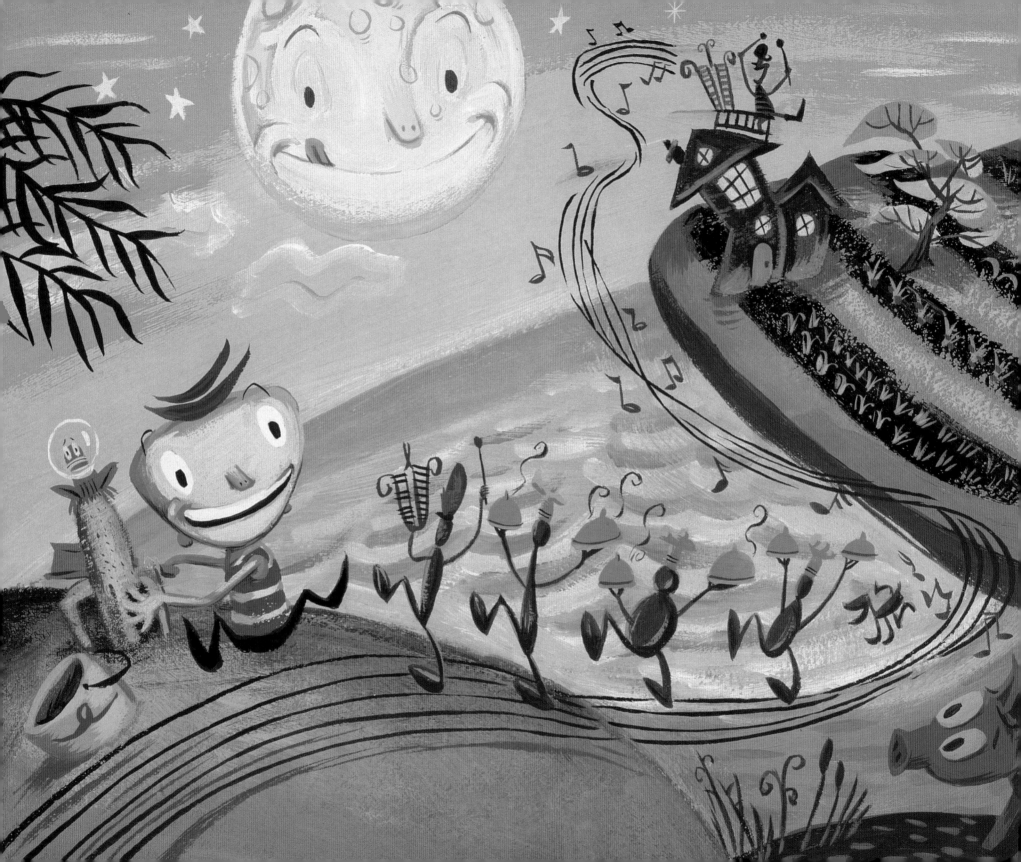

Each evening when the Moon came out, Aunt Fay called Isaac to dinner by playing her glockenspiel.

Glock, Glock, ping-dong-spiel! it went.

Isaac would quickly make his way back to Aunt Fay and Uncle Snog's house--unless Aunt Fay was serving brussels sprouts. Then Isaac went *very* slowly. But no matter how long he took, Isaac always made sure to say "Hi!" to the Moon along the way.

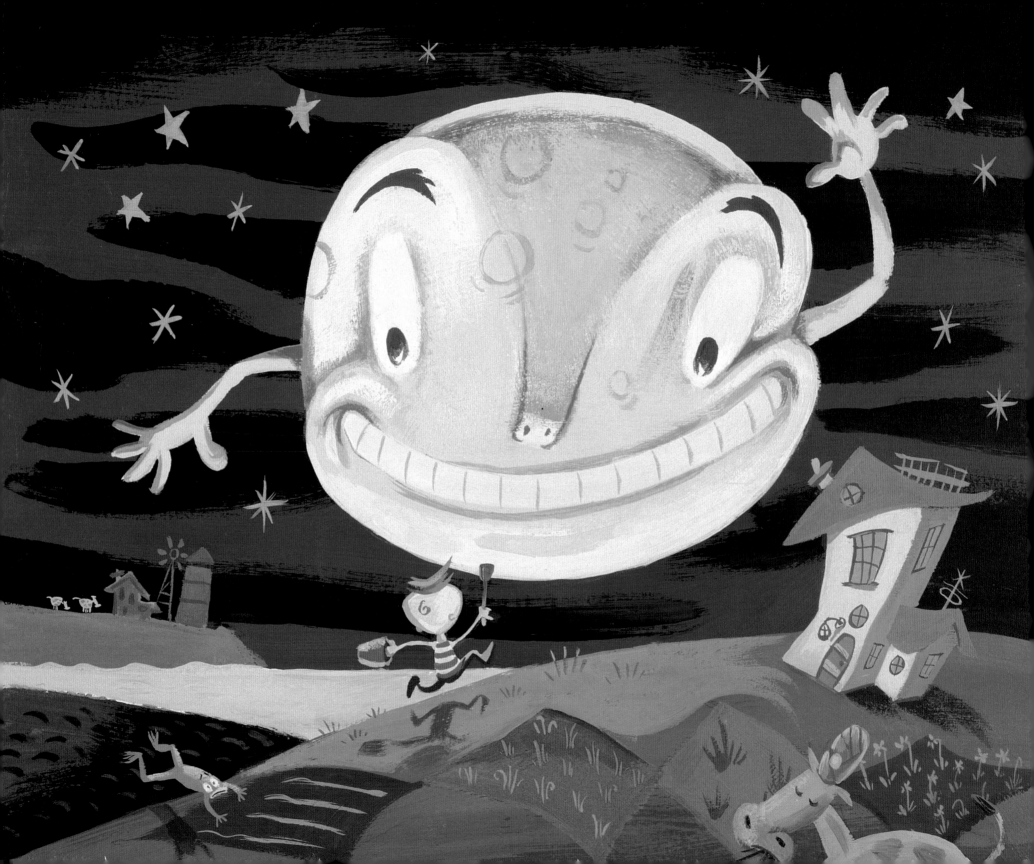

"Hellllooo there, Mr. Moon," Isaac would yell.

"Hi ya Isaac!" the Moon would reply, flapping his big Moon hand!

Isaac often felt bad about leaving the Moon outside alone. Sure, changing the tides and lighting the night sky kept the Moon very busy. But to Isaac, being the Moon seemed like a lonely job.

Yes. Quite lonely indeed.

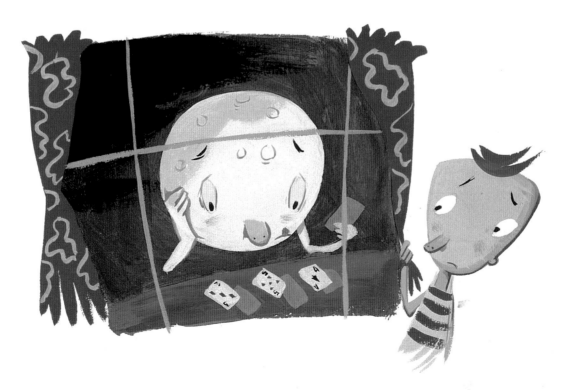

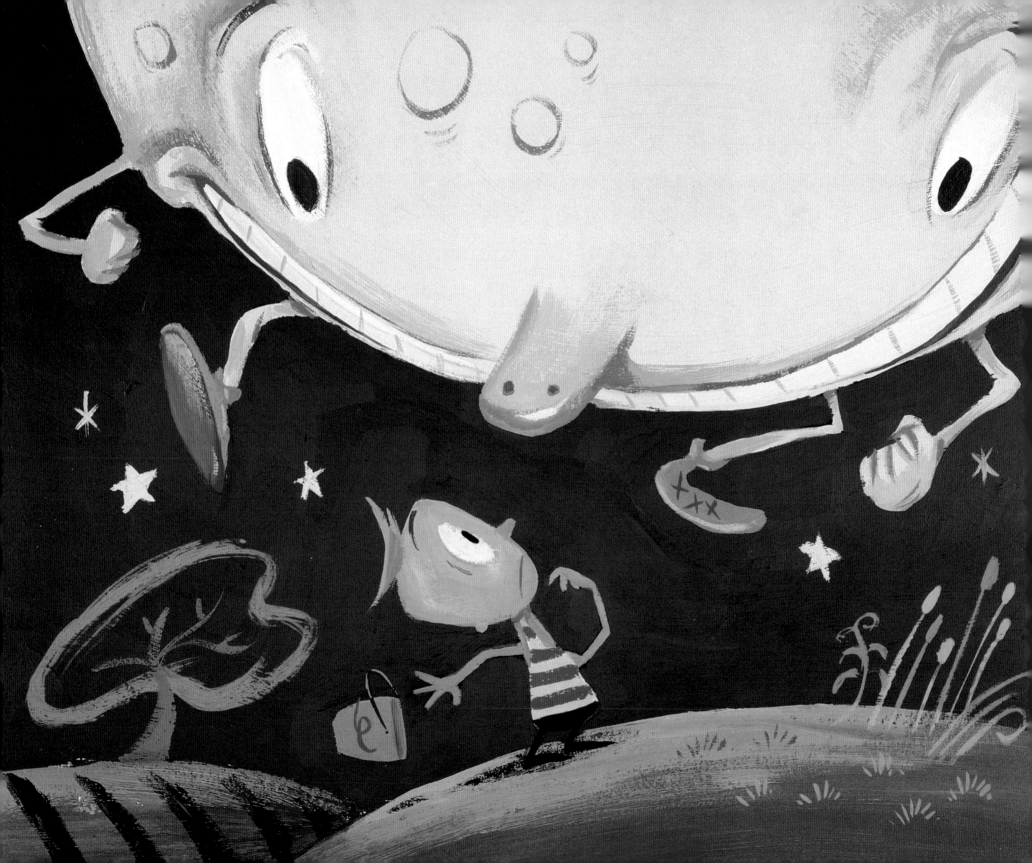

One evening, Isaac asked the Moon if he would like to come to dinner sometime.

"Would I?" grinned the Moon. "You **BET** I would! I'll be **RIGHT** over!"

The Moon had misunderstood. Isaac did not mean *that* night. Isaac did not have Aunt Fay's permission and Uncle Snog still had not come home from work. Isaac ran to the house as fast as he could.

But it was too late.

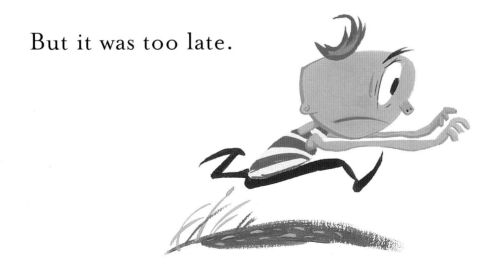

The Moon was already stuck in Aunt Fay's doorway.

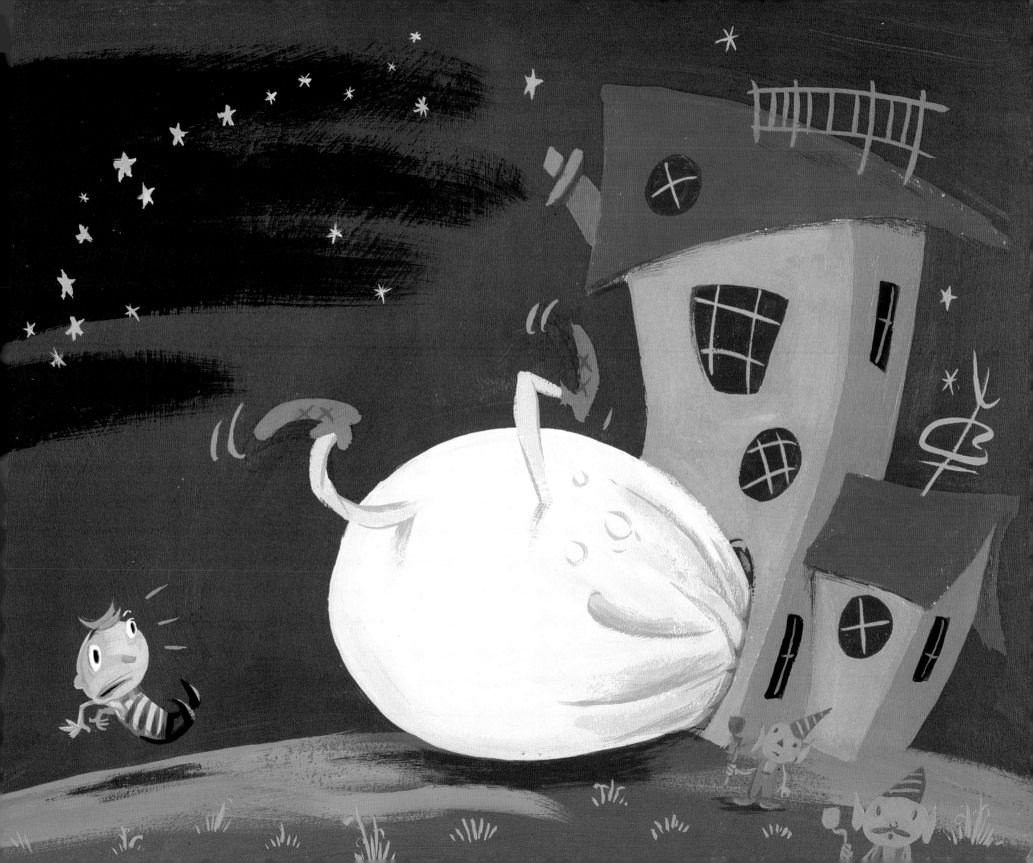

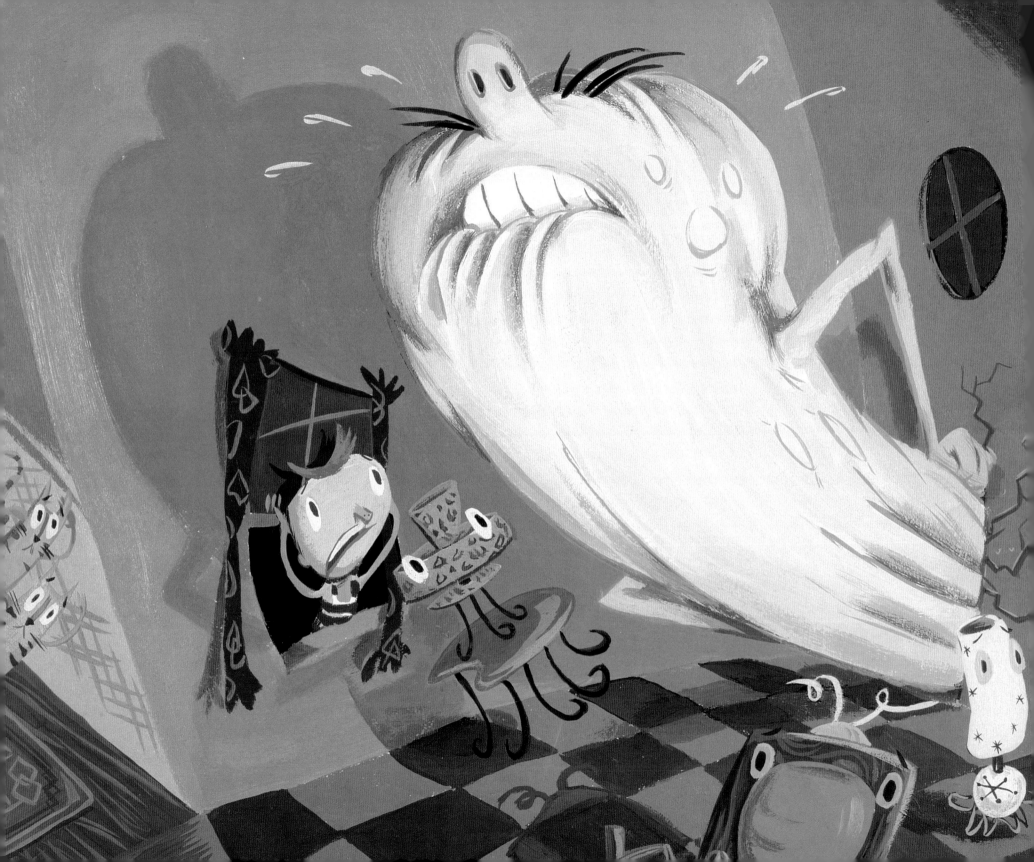

"Mr. Moon, you misunderstood me," Isaac pleaded. The Moon was not listening. He **GRUNTED** and **SQUEEEEEZED**. He **HUFFED** and he **WHEEEEZED**. Suddenly, after a loud **CRACK-CRASH**, there was a large Moon-shaped hole where the door had once been.

"Oh, no!" frowned Isaac, looking at the damage. "Aunt Fay and Uncle Snog will not like this!"

But the Moon had just begun.

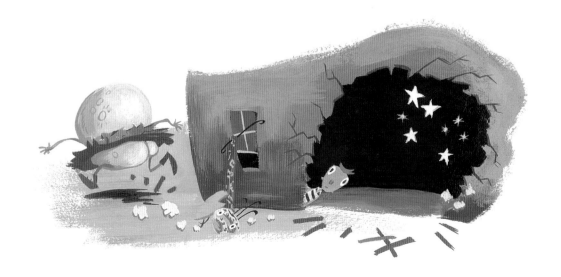

"**SCREAM!!!**" went Aunt Fay, sending biscuits flying to the ceiling. Isaac ran into the dining room and found the Moon with his stinky socks up on the dinner table and Aunt Fay putting her wig back on.

"**WHO ASKED THE MOON TO DINNER?**" cried Aunt Fay, as she ran down the hall to the safety of her bedroom. Isaac followed, desperately wanting to explain. He was stopped by the sound of breaking dishes.

"Surely that's the last of it," Isaac thought hopefully, referring to the Moon's clumsiness.

 But no, the moon was *not* finished.

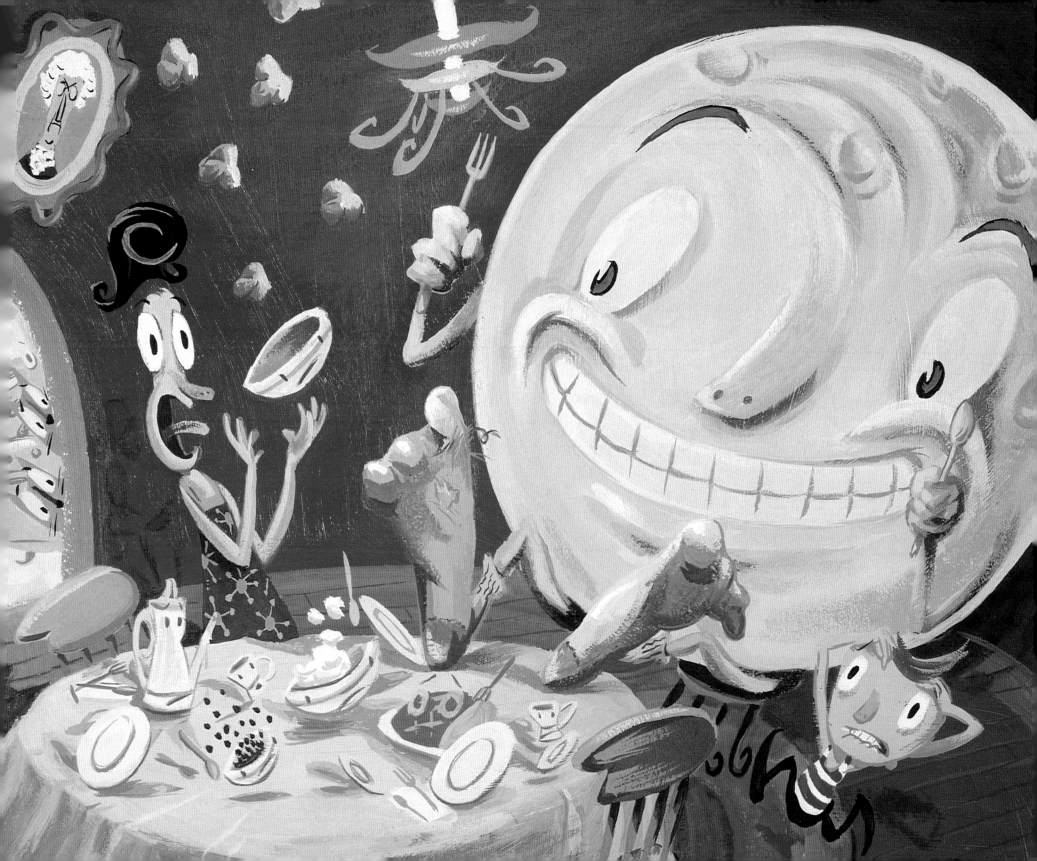

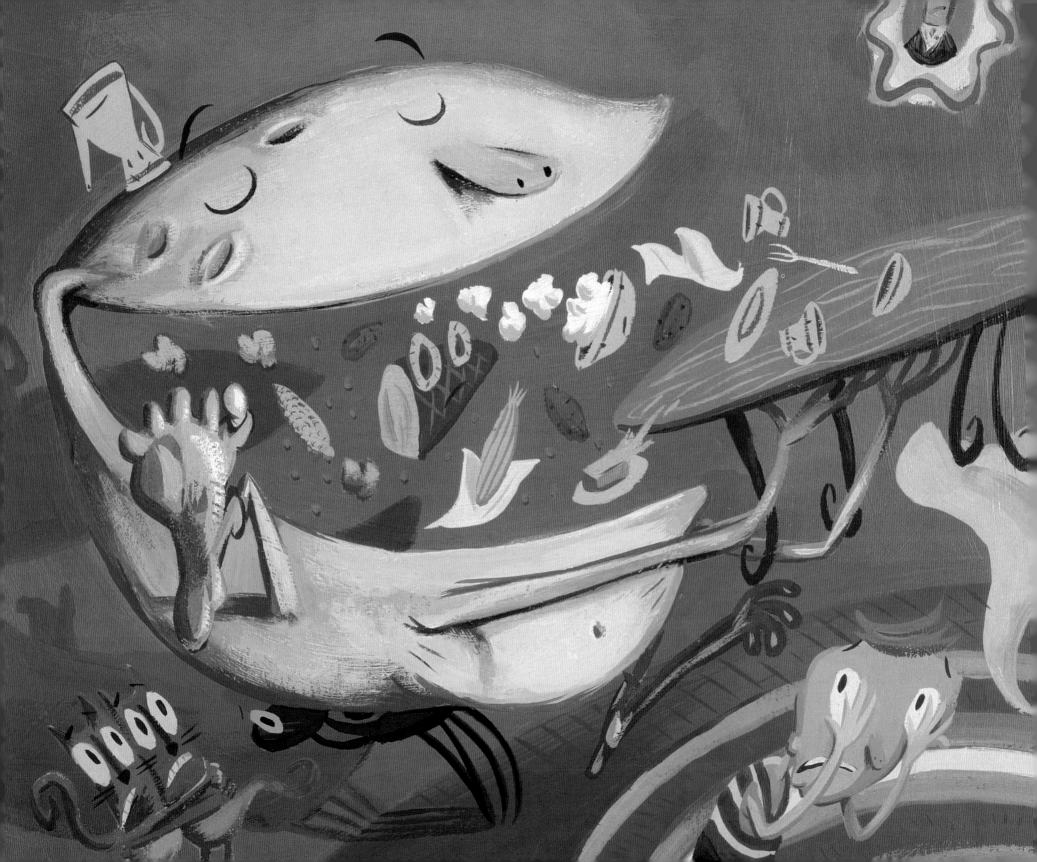

When Isaac returned to the dining room, he found the Moon leaning back in his chair gobbling up everyone's meal, his belly growing larger by the second. *Then* the Moon let out a **BURP** so LOUD, it knocked the painting of Great-Grandma Smidge right off the wall.

SLAM!-CRASH! went the painting.

CRACK! went the Moon's chair, breaking under his weight. **BOOM!** went the Moon, falling to the floor and sending a cloud of Moon-dust throughout the house.

"This was not a good idea," thought Isaac. "Aunt Fay and Uncle Snog will **NOT** like this."

But the Moon *still* was not finished.

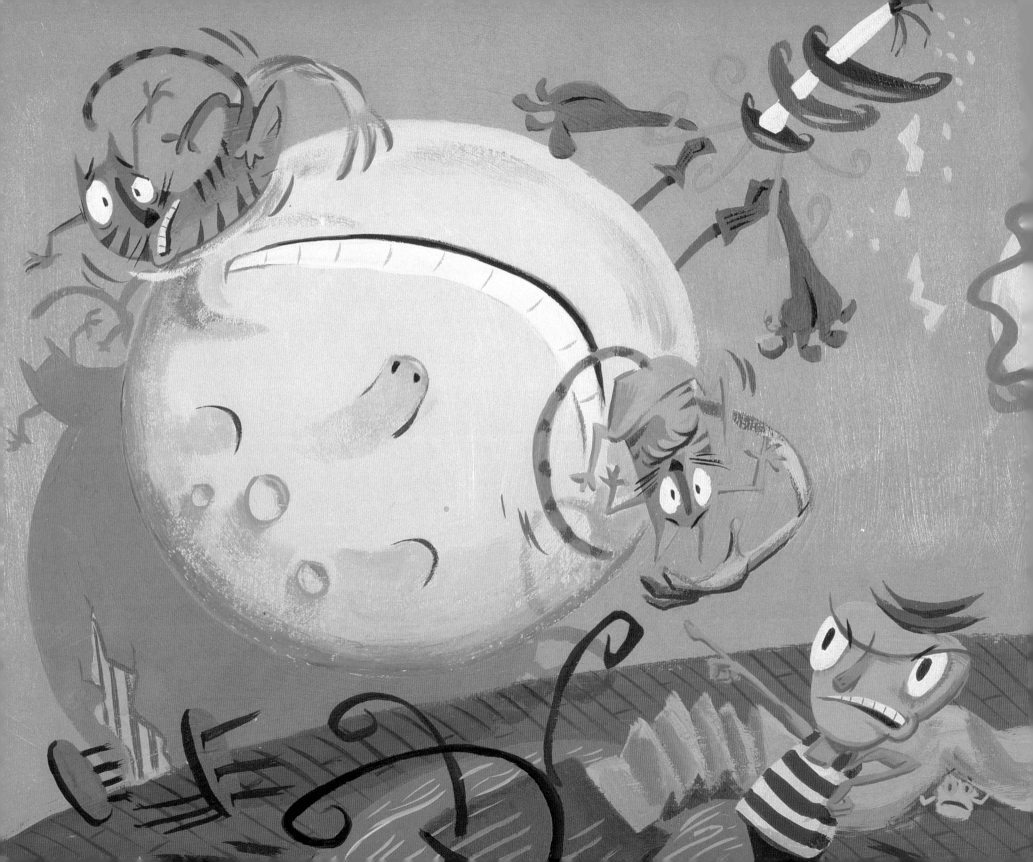

After blowing his nose with the tablecloth, the Moon began swinging upside down from the chandelier, juggling Aunt Fay's cats and humming the Star Spangled Banner!

"YEEEEOW! YEEEEOW! YEEEEOWW!" sang the cats.

Isaac thought this had gone far enough. The house was a wreck and Uncle Snog was due home from work any minute! And Isaac was SURE his Aunt Fay would disapprove of her cats being juggled.

"Mr. Moon," Isaac scolded. "You have been the rudest dinner guest I have **EVER** seen!! It's time for you to **LEAVE!**"

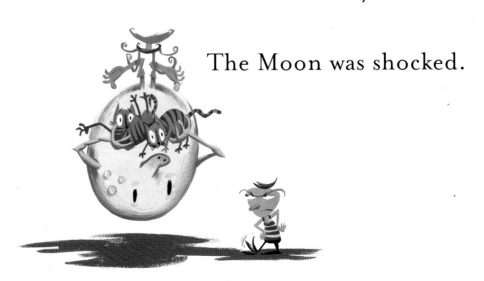 The Moon was shocked.

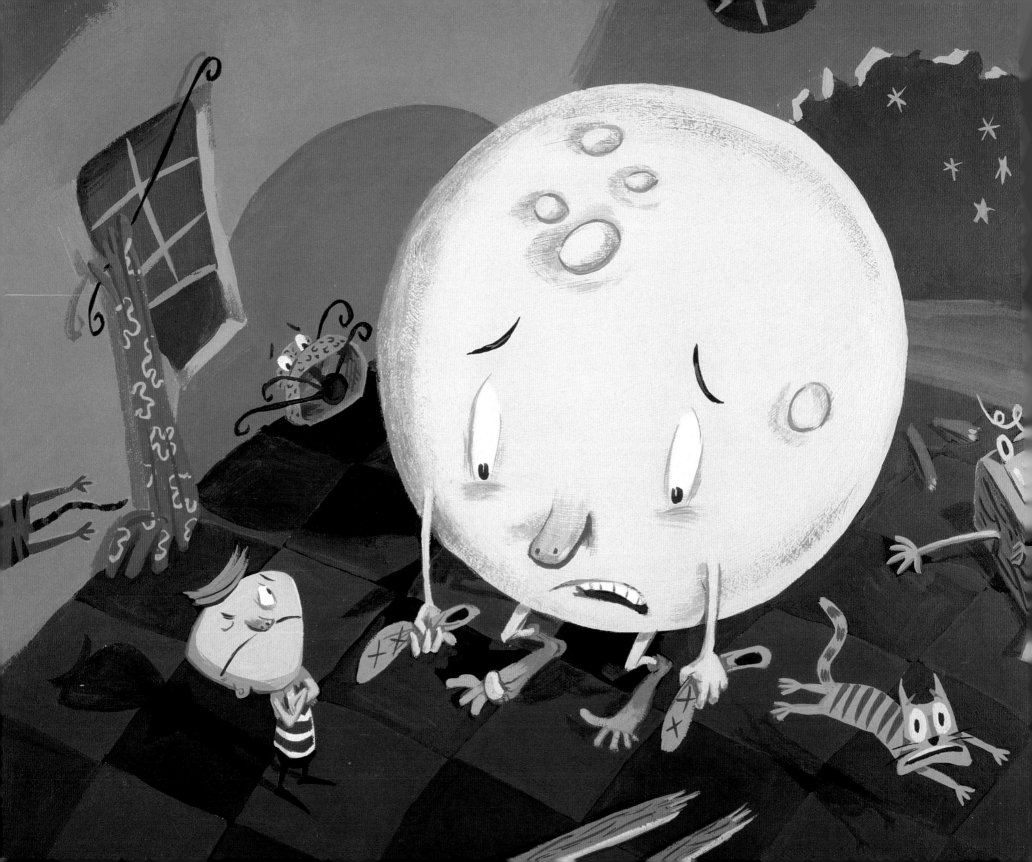

Feeling quite ashamed, the Moon put the cats down, picked up his shoes and sadly walked towards the hole in the doorway.

"I'm SORRY Isaac. I've never been asked to dinner before," the Moon confessed. "Nobody has ever taught me what to do."

Isaac watched the Moon bow his head and shuffle down the walkway, his glow *fading* and *flickering* with each step.

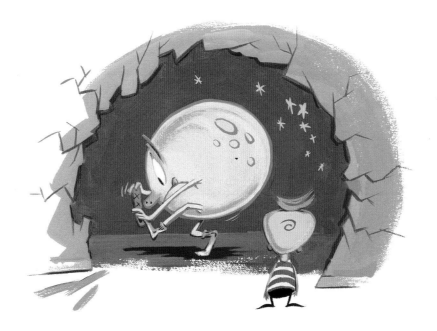

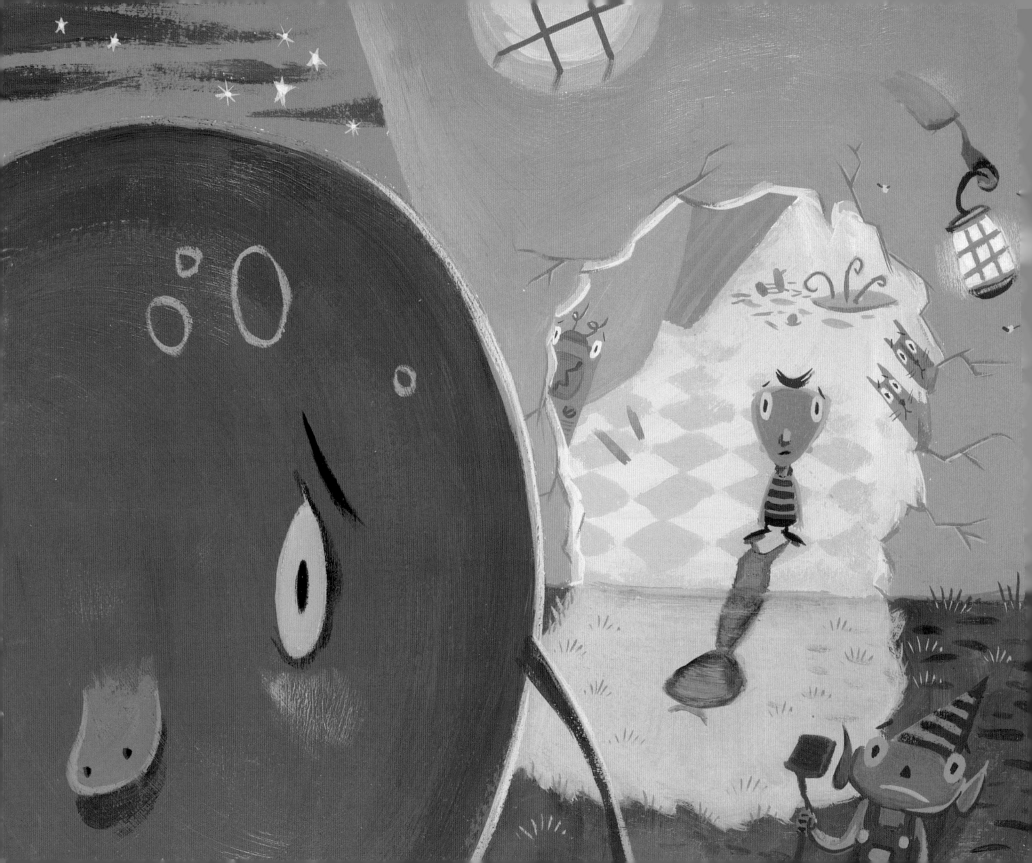

"**Mr. Moon**?" Isaac called out.

The Moon sadly turned towards Isaac.

"I don't always have the best manners myself," Isaac admitted. "But I can teach you what I know."

"**REALLY?**" asked the Moon as his eyeballs began to b͏ounce with joy.

"But *first,*" Isaac continued, "you have to fix the damage you've done before my Uncle Snog gets home."

"You **BETCHA!!**" the Moon beamed, shimmering with a light so bright the cats had to wear sunglasses.

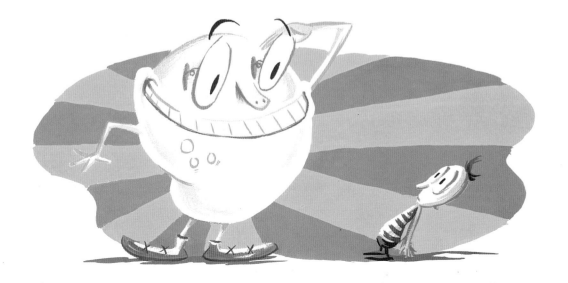

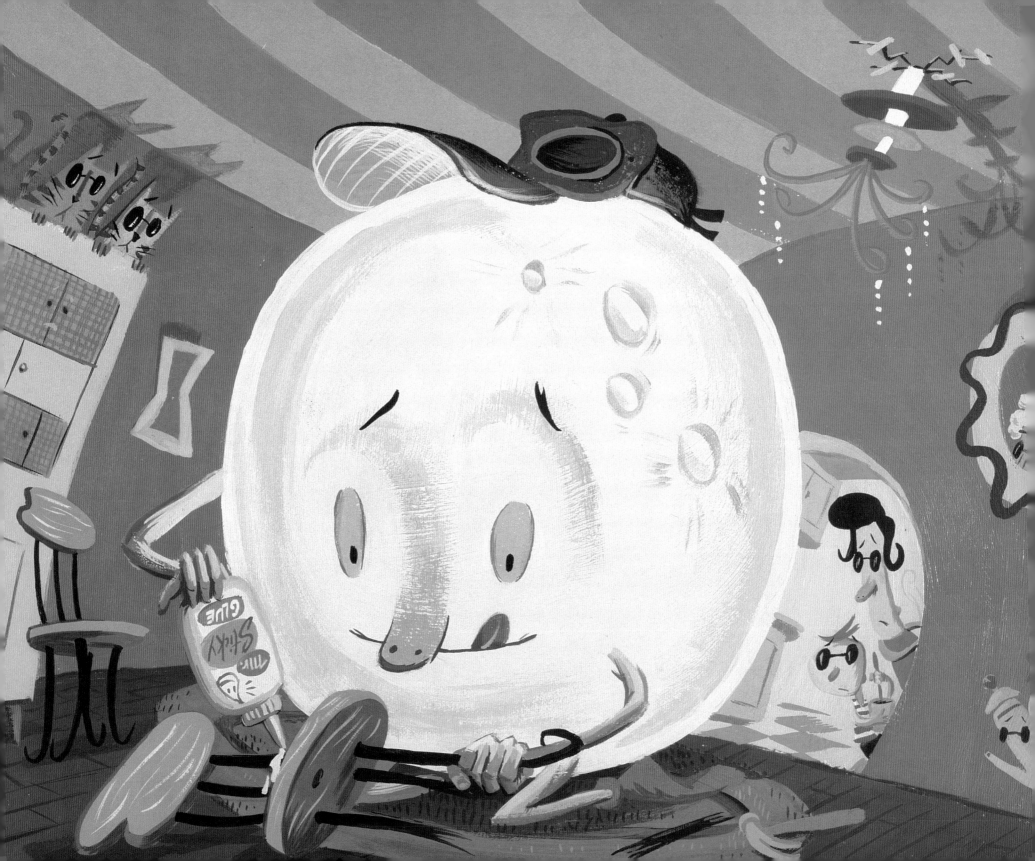

The Moon immediately went to work repairing his Moon wreckage while Isaac helped Aunt Fay re-make dinner and pull the biscuits out of her wig.

Then Isaac sat down with the Moon to show him how to eat his *own* dinner and..oh yeah.. to use a knife and a fork. Isaac also coached the Moon on polite dinner conversation, kindness to animals and how to use a handkerchief if he simply insisted upon b l o w i n g his nose.

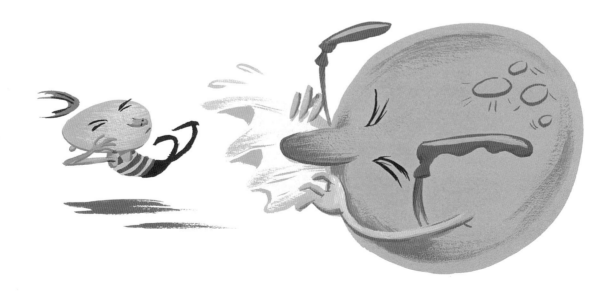

"And what have we here?" smiled Uncle Snog, as he walked through the newly-fixed doorway. **"A dinner guest?"**

"This is Mr. Moon," Isaac announced. The Moon bowed.

Aunt Fay played her glockenspiel.

Glock!Glock! Ping-dong-spiel! it went.

"Splendid," said Uncle Snog. **"LET'S EAT!"**

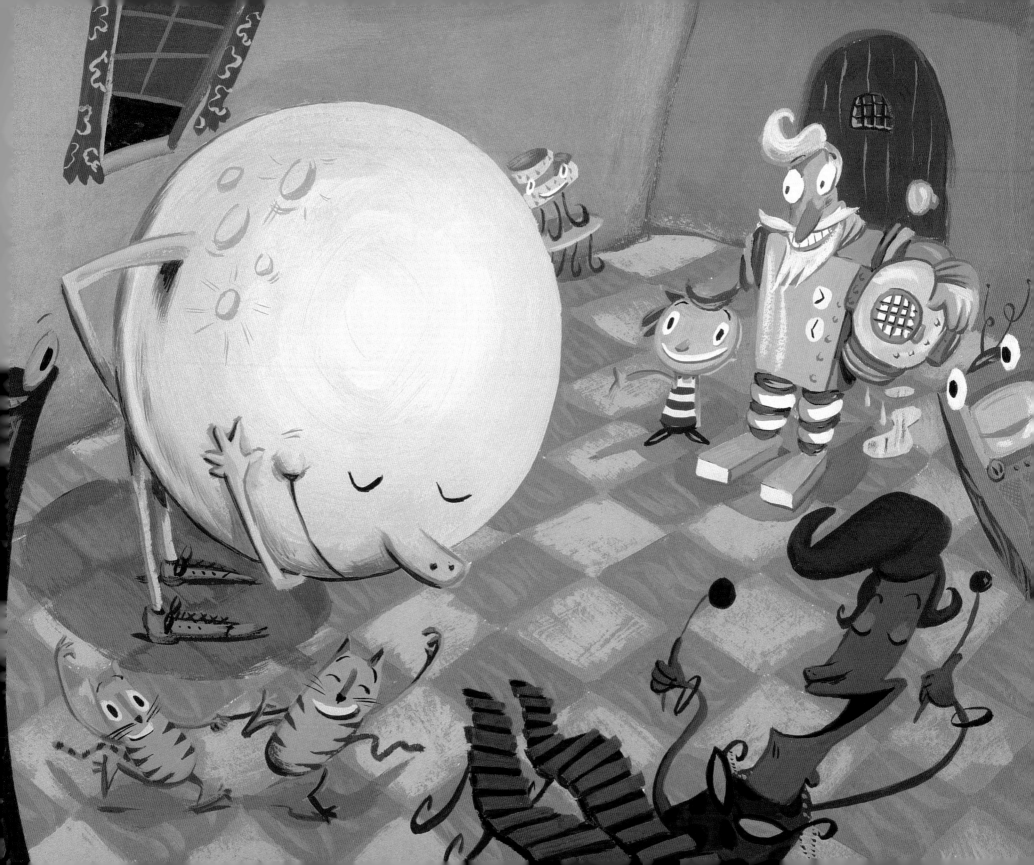

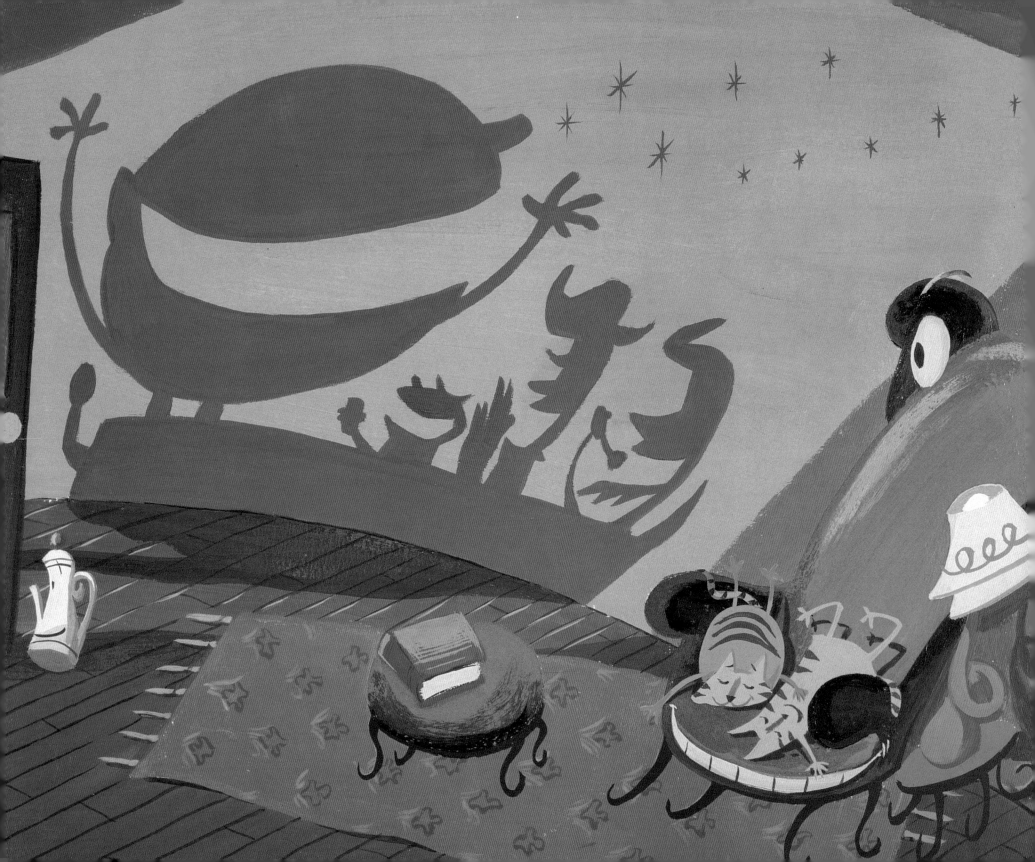

Isaac, Uncle Snog and Aunt Fay sat down to a *delightful* dinner as the Moon serenaded them with his version of *Moon River* (slightly off-key) and told stories of mysterious jumping cows.

The Moon was very well-mannered as he ate and even helped clear the dishes.

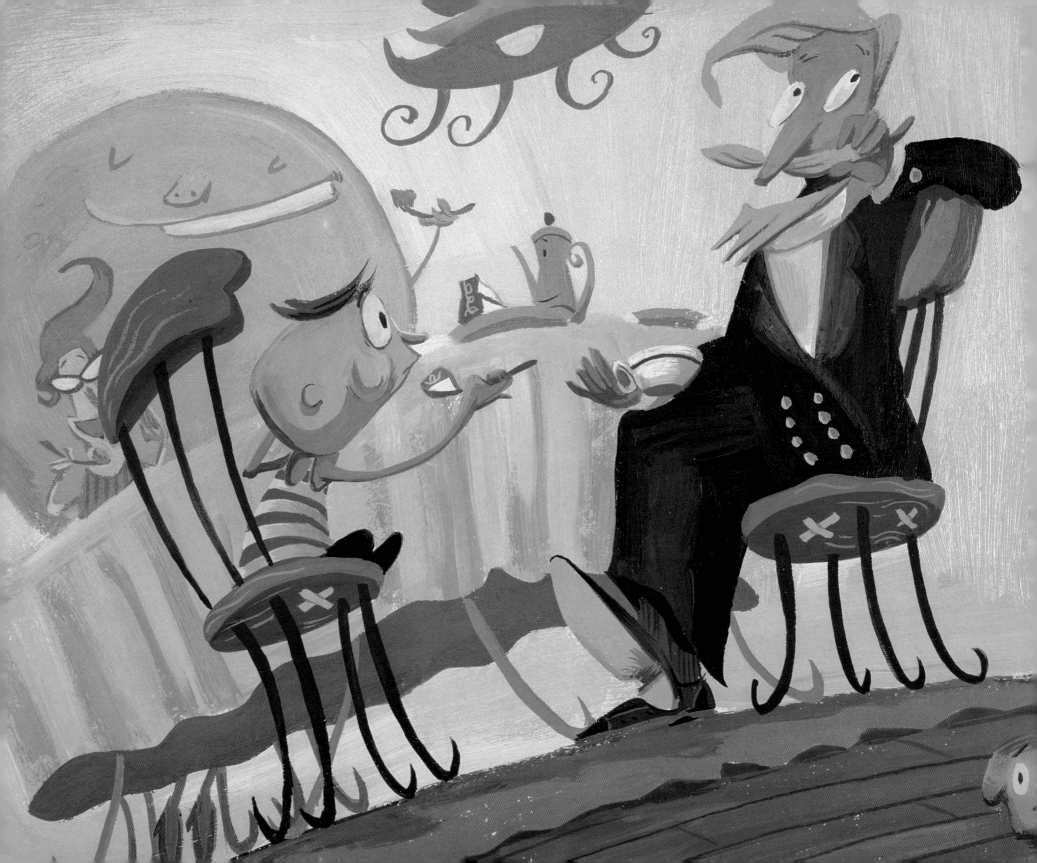

Uncle Snog was quite taken with the Moon. He thought asking the Moon to dinner was a GREAT idea and should be done often. A proud Isaac caught the Moon's eye with an approving nod. The Moon smiled at Isaac before quickly returning to his conversation with Aunt Fay about her favorite cheeses.

Then Uncle Snog leaned back, stroked his mustache and chuckled. "You know, the Moon has been such a *lovely* guest, maybe tomorrow we should ask THE SUN to breakfast."

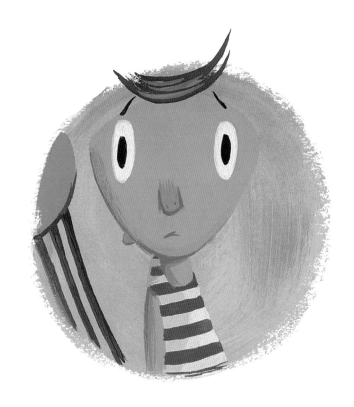

Isaac gulped and quietly alerted the fire department.